逐光
紀影

許義榮

自序

從沒想過出版攝影集，因為拍照只是生活中的小興趣，攝影時也不是使用專業的單眼相機，而是幾乎人人都有的 iphone 手機。我喜歡欣賞美的事物，當我發現拍照不僅是紀念，那瞬間魅力還可以創造出獨特的美時，我就開始喜歡它了！不管是人物、靜物、風景、水、草、花、樹、甚至於光和影……，很自然地會在我眼中構成奇特的輪廓並停格在我的映象裡，而成為我快門下的作品。

說起拍照的緣起，可一點也不浪漫，一開始只是為了幫公司蒐集樣品，百貨公司或是 Shopping mall 展示櫥窗內的泳裝都是我拍照的素材，還曾和太太一下飛機包車一整天只為了拍到好的 Sample，因此，說拍了成千上萬張照片可一點也不誇張，後來公司要引進新的機器設備，每當參訪工廠或看展覽時，我會拍攝機器或是操作員的模板動作提供員工研發與學習的機會，所以拍照真的只是為了工作，但或許是累積的經驗，慢慢讓我發現這箇中奧妙；這些年和太太國內、外旅遊，也參觀世界各地的美術館、博物館，讓我漸漸學會如何欣賞建築物和藝術品，慢慢地，我學會掌鏡，運用不同的拍攝角度就會呈現不同的光和影，拍攝出的畫面會隨之不同，猶如創造出新的藝術品令人讚嘆與驚喜，讓人想要收藏，就這樣開啟了攝影的美麗人生。

有朋友曾問我，是否學過拍照技巧或閱讀過專業攝影書籍？其實沒有，但當我看到網路或朋友分享一些不錯的照片時，我會蒐集並重複觀看予以研究與思考：攝影者是如何運鏡與構圖（色彩、空間、光影、線條、形狀），進而去仿效運用到我下一張作品的拍攝中，就這樣我也慢慢變成無師自通了……。

我喜歡當代藝術，因此，攝影集裡您會發現很多格子、光、影、水波紋的照片都呈現在我的作品中。今年我八十歲了，也是信源企業創立五十週年，在這個特別的日子與親朋好友們的鼓勵下，挑選了 80 張照片與您分享美的視野，攝影是瞬間的藝術，只有長期積累，才能得於偶然，希望欣賞照片的同時，也能帶您進入美的世界。

下次若遇到我停在路邊，拿著手機忘我拍照時，請不要太過驚訝，不妨加入我的視界，若您願意停下腳步欣賞，就會發現，原來這個世界有多精彩……。

最後，我要由衷感謝好友余建新（Albert）先生的鼓勵與支持，以及協助出版與編輯的趙政岷先生和梁小良先生，以專業與藝術的角度，成就了這本美麗的攝影集。

Preface

I never thought I would one day publish my own photo collection. For me, photography has always just been a hobby. I don't even use a professional SLR camera, just my iPhone, something that nearly everyone has in their pockets. I appreciate beauty, so my interest in photography really blossomed when I realized that taking a picture is not just to document a moment in time but it also captures the beauty of that very moment. Whether it is a portrait, still life, landscape, water, grass, flower, tree, or even light and shadow, I enjoy capturing the scenes with the click of my shutter, freezing the moments and creating my own art.

Speaking of how I started photography, it really is nothing overly romantic. At first, I took photos merely to collect samples for my work, taking shots of things like swimwear displayed at department stores or shopping malls. I remember I once chartered a car with my wife just to take photos of product samples at various retail stores, and it would not be an exaggeration to say that I probably took thousands of photos just to get a few perfect shots. Later, when my

company introduced new production machinery at our factories, I would take pictures of sewing operators using the machines at trade shows as well as during factory visits so that I could share the photos with my employees to study the technical details. During that time, I took photos mainly for my job.

It was sometime after accumulating a bit of experience that I slowly began to be fascinated by photography as a personal expression. In recent years when my wife and I travelled to art galleries and museums in Taiwan and abroad, I became more and more exposed to not just famous works of art, including architecture, paintings, and sculptures, but also to the art of photography. It turns out photography as a medium of expression can both surprise and delight. So I started to experiment further and began to compile my own collection. Thus, I embarked on this beautiful journey into the world of photography.

A friend once asked me if I had ever taken photography classes or consulted any professional photography textbooks. The answer is no. However, when I see a good photo I like I study it carefully to understand how the photographer positions the camera, plays with the composition, or incorporates elements of color, space, light, shadow, contour, and shape. I then try to imitate and apply these observations in my own work, eventually becoming a self-taught photographer.

To mark both my 80th birthday and the 50th anniversary of the founding of RSI, and with the encouragement from my dear family and friends, I have selected 80 photos to share my personal vision of beauty with you. I particularly enjoy contemporary art, so in this collection you will find a lot of light and shadow, grids, and even water ripples. Photography is an art form that captures the fleeting moments of life, and I want to share with you some of my own personal moments of eternal beauty. I hope these photos are enjoyable to you and opens your eyes to a world of beauty and wonder.

Next time you see me stopping on the side of the road to take a photo with my cell phone, please do not be too surprised. This is an invitation for you to stop as well and take a look through my view of the world. If you make the time to really look around, you will for sure discover what a wonderful world it is we live in.

暮光中的台北 101。〈台北〉

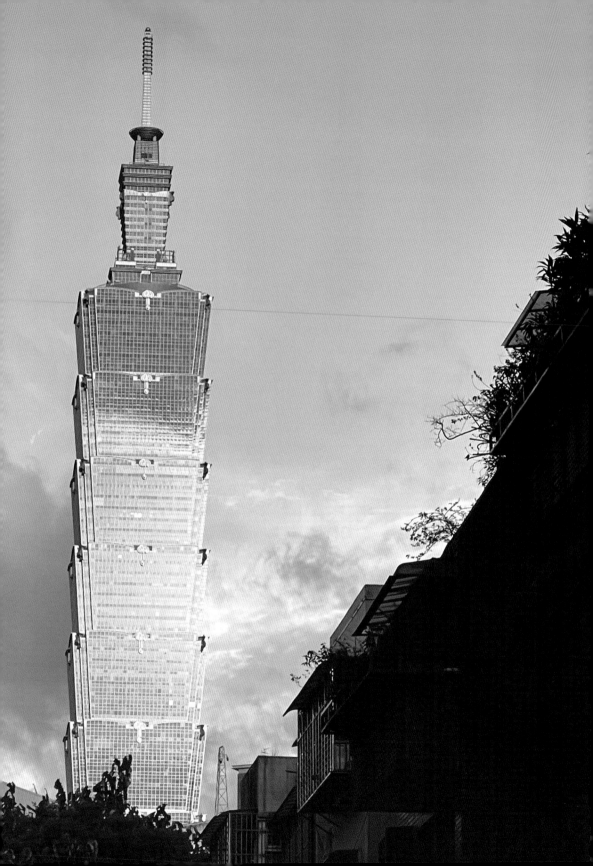

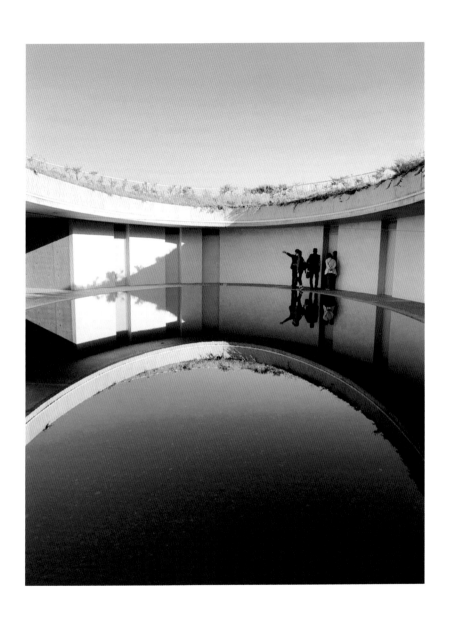

水靜如鏡令人醉。〈日本 · 瀨戶內海 Oval〉　　15

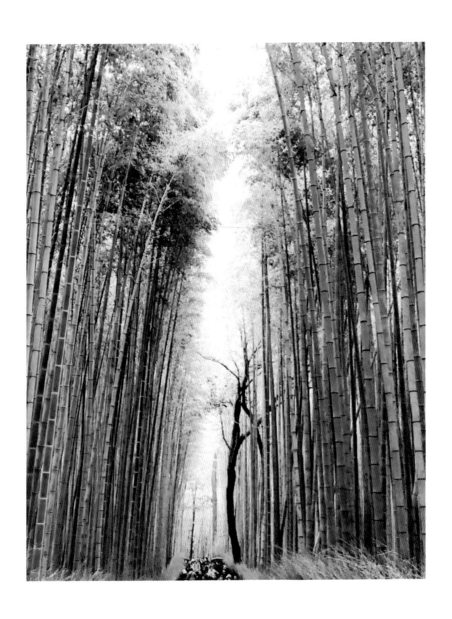

竹風蕭蕭構成了人間無雙的奇景。〈日本 · 京都〉　　17

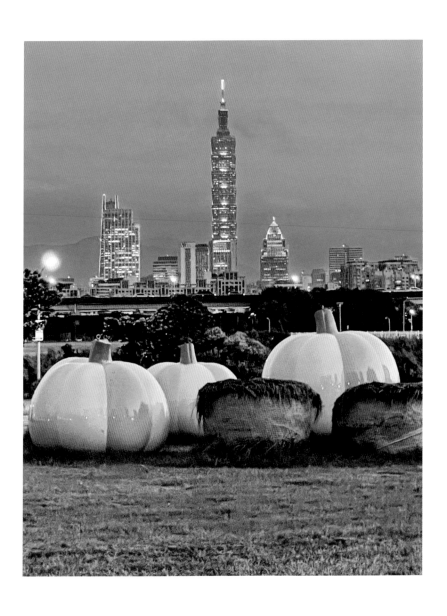

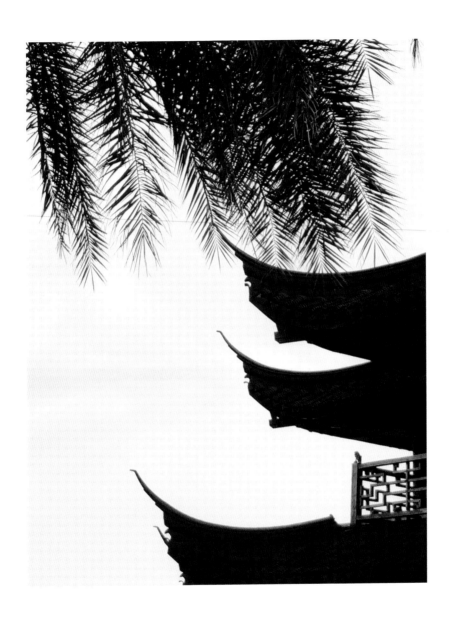

翩翩風柔軟的吹過。〈宜蘭・阿拉伯皇宮〉　　21

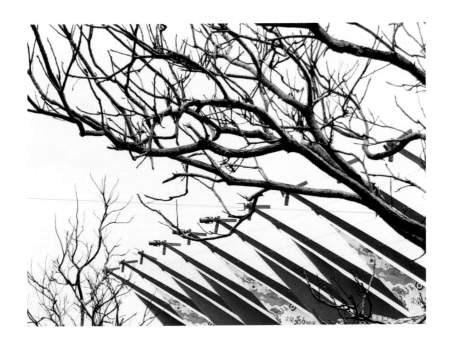

樹梢滿枝奔發，有如頭角崢嶸之勢。〈宜蘭 · 蘭陽博物館〉　　23

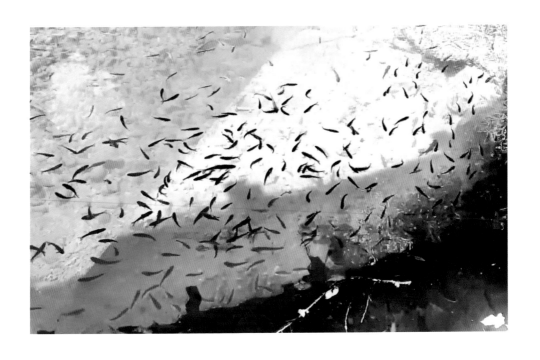

魚游魚泳在碧波綠水中。〈溪頭 · 杉林溪〉　　25

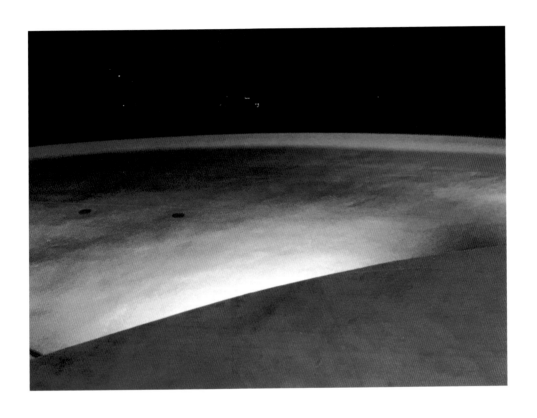

這是最超現實的奇幻人間域境。〈美國 · 夏威夷私人收藏家的游泳池〉　　27

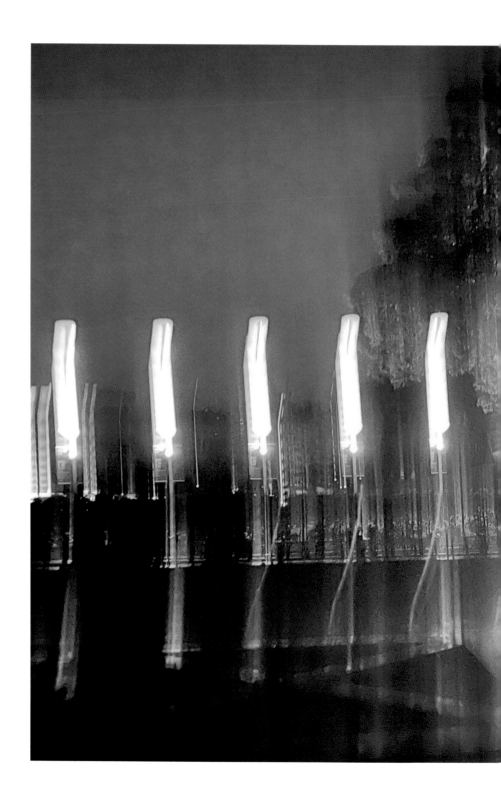

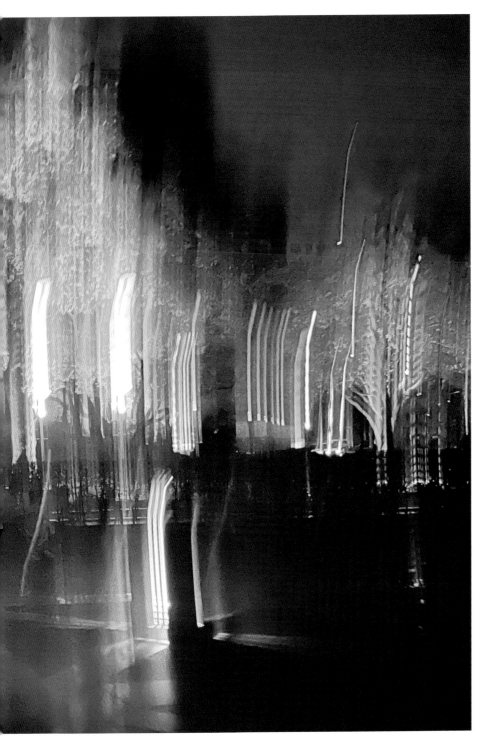

燈影柳浪在暗夜中飛舞絢麗的光芒。〈花蓮〉　　29

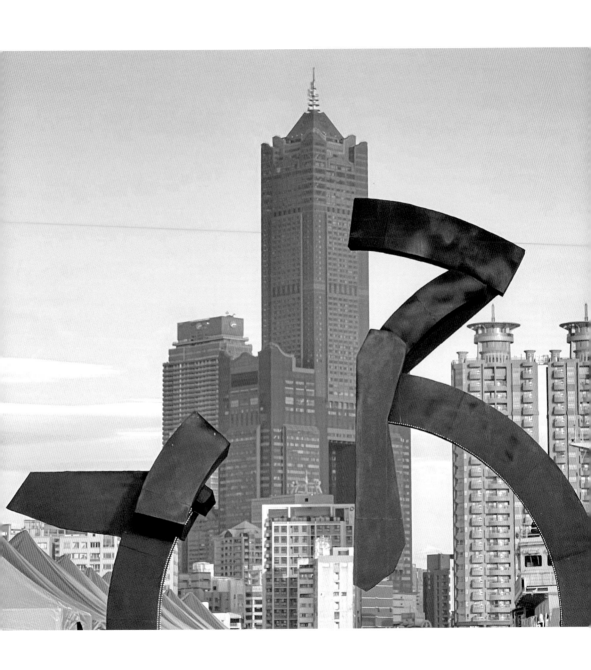

高傲的姿態矗立萬丈高樓叢林中。〈高雄〉 31

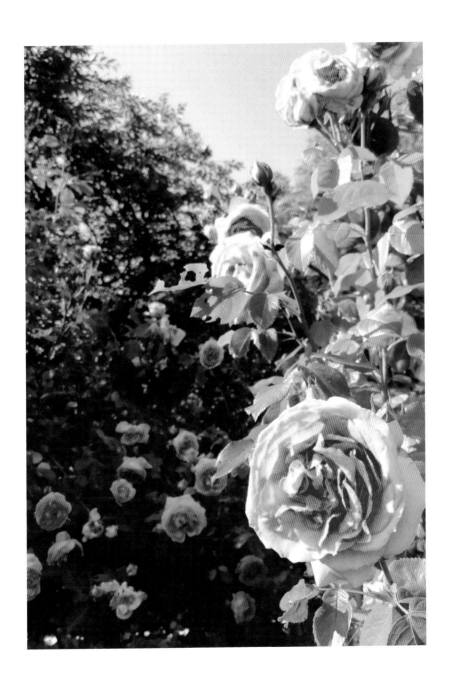

嫩粉鮮麗花容，恰似黛綠年華之姿。〈歐洲〉

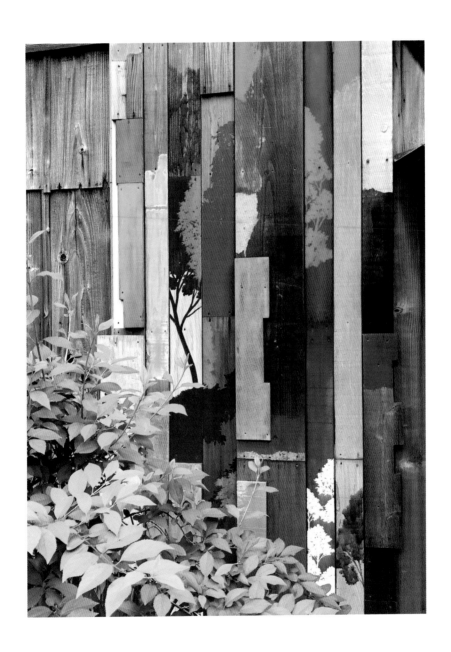

板牆多彩繽紛姿顏，令人無法轉移目光。〈日本〉

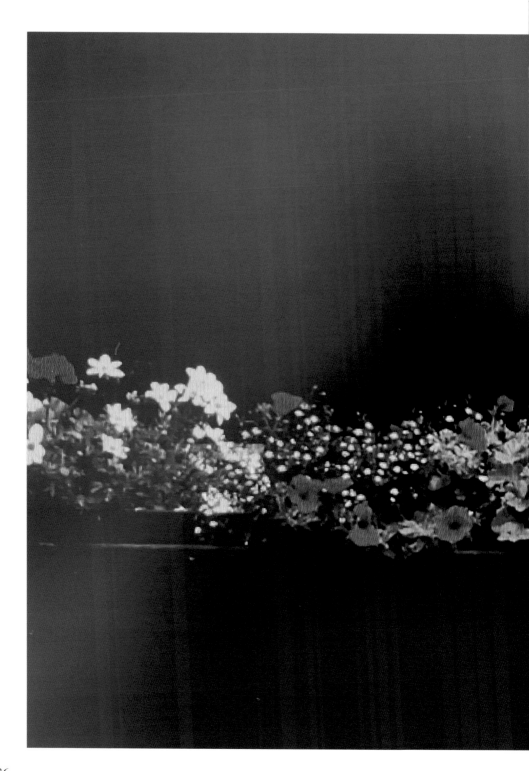

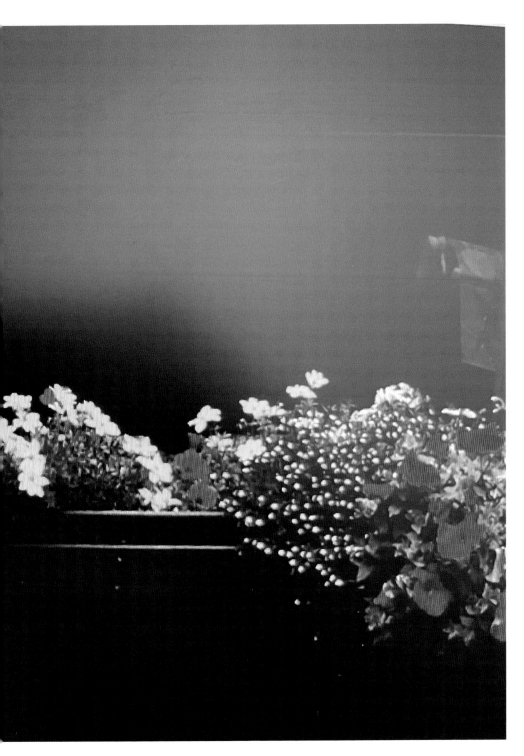

春城無處不飛花。〈斯洛伐克 · 什特爾巴斯卡湖〉

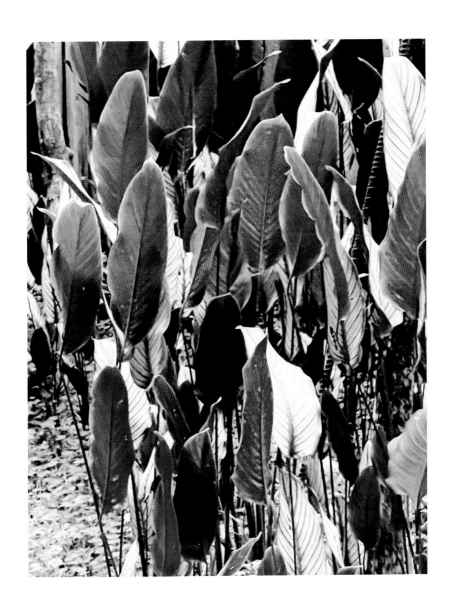

枝葉散發出多彩的姿容。〈南投 · 秋山居〉　　39

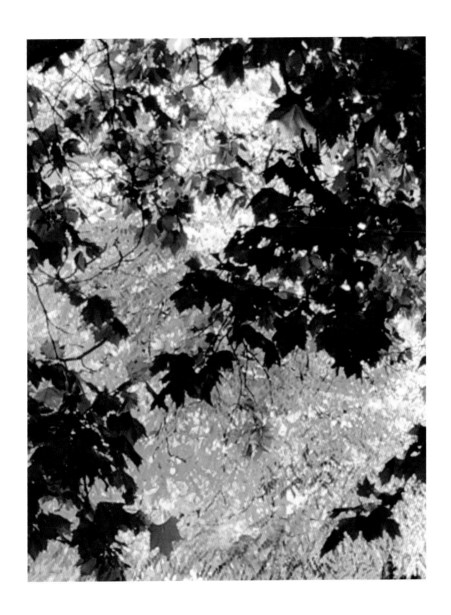

陽光流瀉瑩潔晶燦的嫵媚。〈南投 · 杉林溪〉　　41

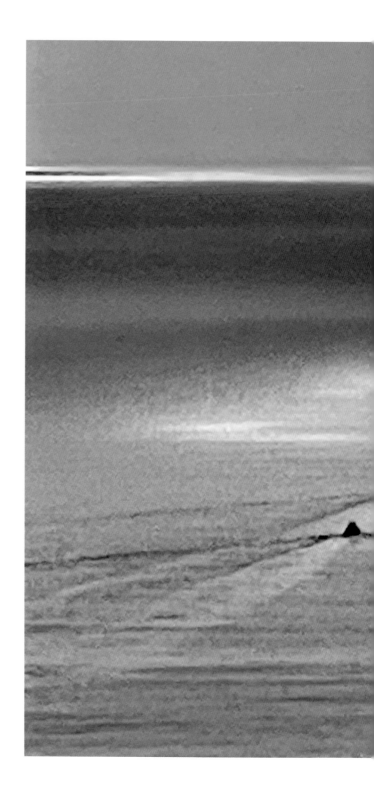

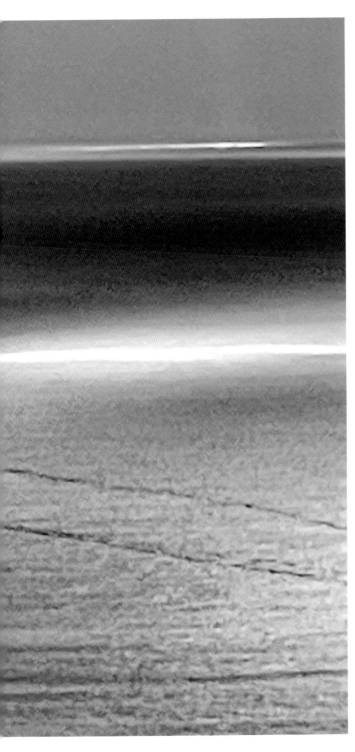

輕舟划動水之漣漪，漫遊在無盡海天光景裡。〈宜蘭 ‧ villa-R〉

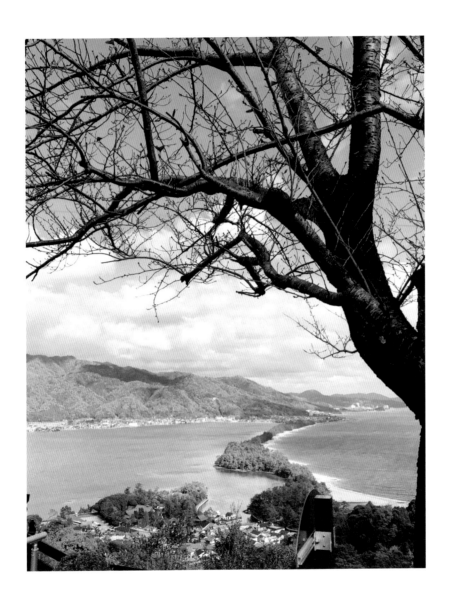

重疊青山環帶碧水盈盈是一幅鮮明的景緻。〈日本〉　　45

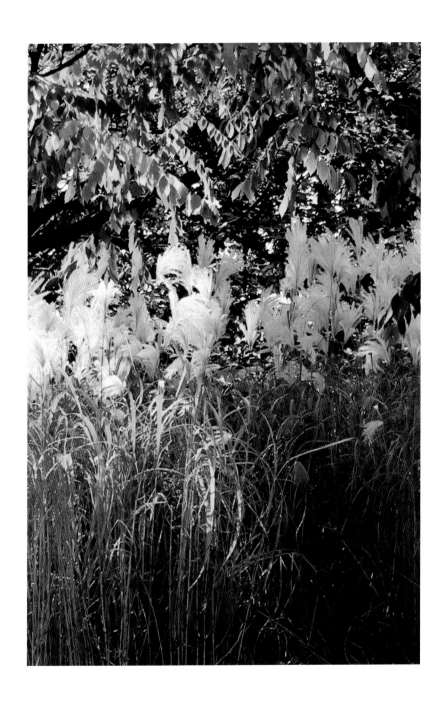

蘆花飛盪在濃郁的秋意中。〈德國〉

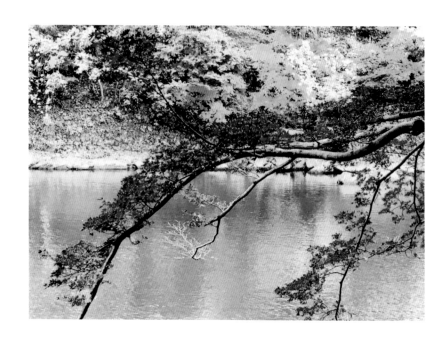

48　　　須待秋風紅葉飛落時。〈日本〉

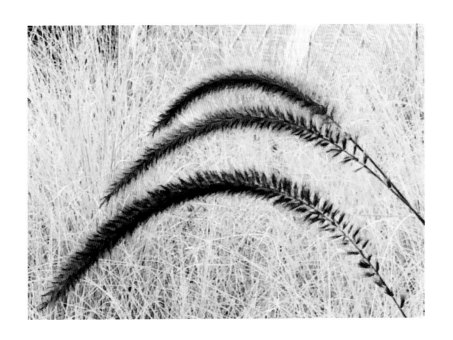

柔軟中躺著享受陽光。〈台南〉　　49

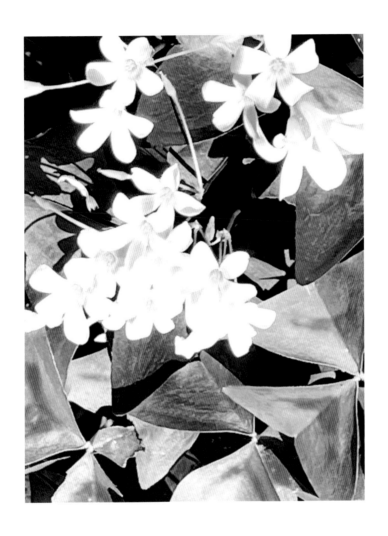

幽香清沁小白花，在大地舞台妝扮清麗的角色。〈宜蘭・頭城〉

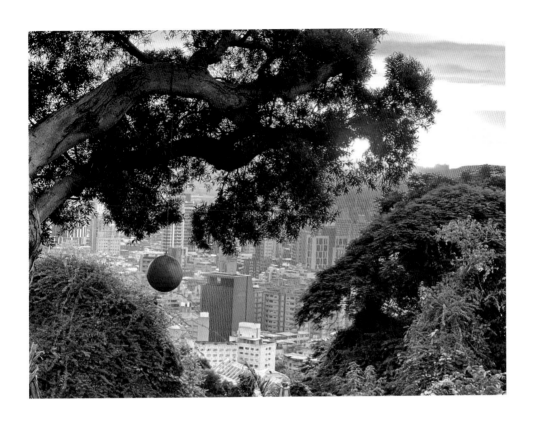

何謂瑜亮針鋒相對情節，現時即刻上演中。〈台北 · 陽明山〉　　53

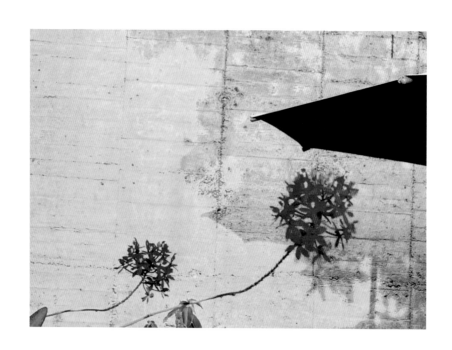

　　花兒，你也想遮陽嗎？〈南投 ・ 秋山居〉

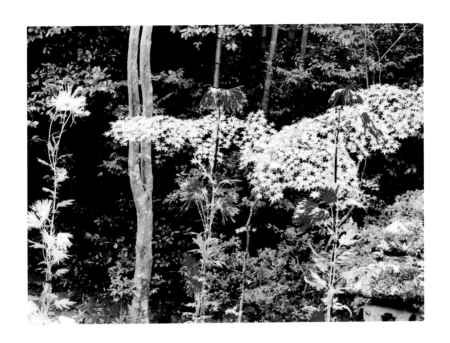

繁花似錦點綴自然的畫布。〈日本〉

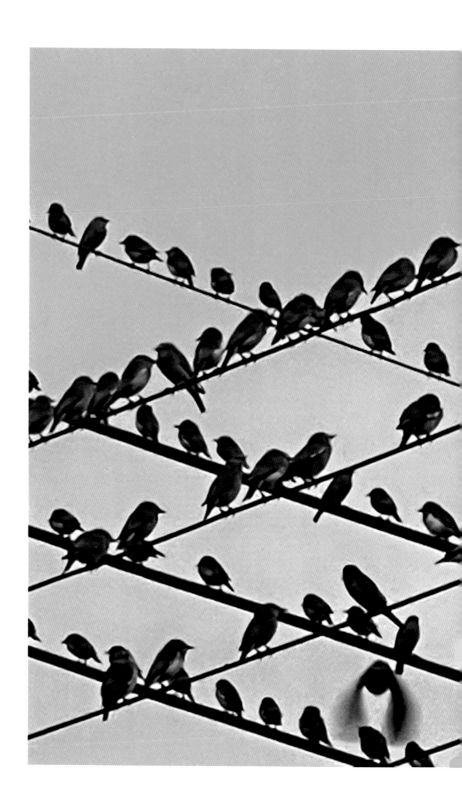

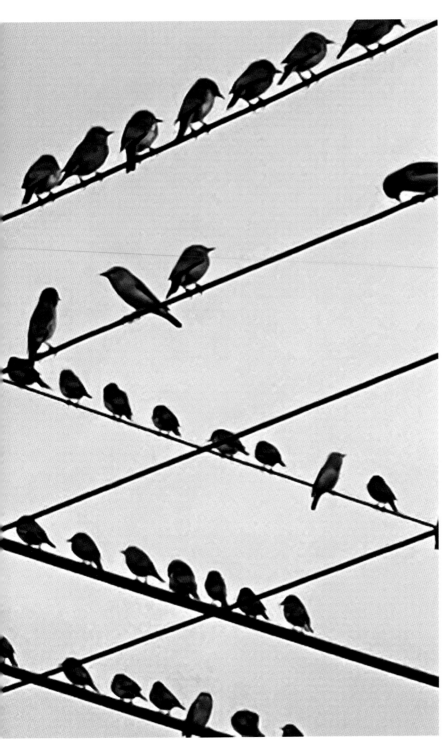

鳥啼，是人間最悦耳的交響樂。〈屏東 · 茉莉亞莊園〉

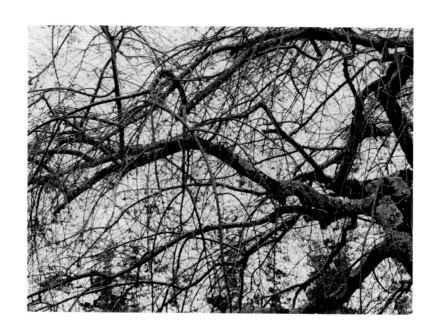

　　　林木的枝葉擠碎陽光。〈台北　‧　堤頂大道〉

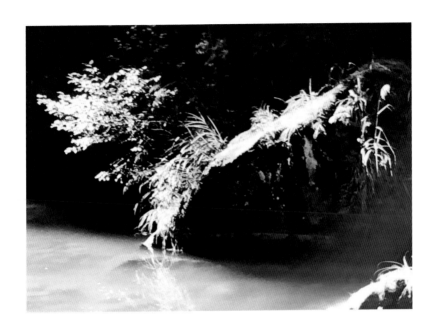

微光灑落陪伴著湖水。〈南投 ‧ 溪頭〉

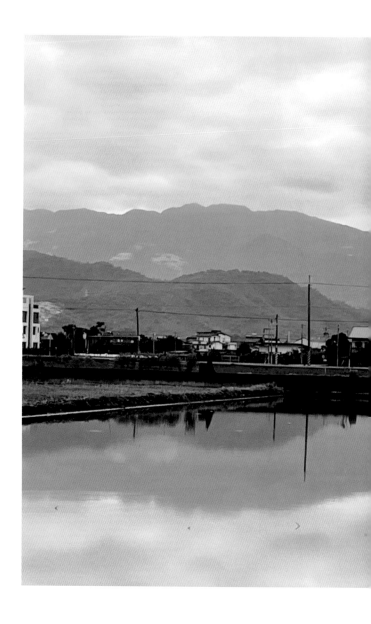

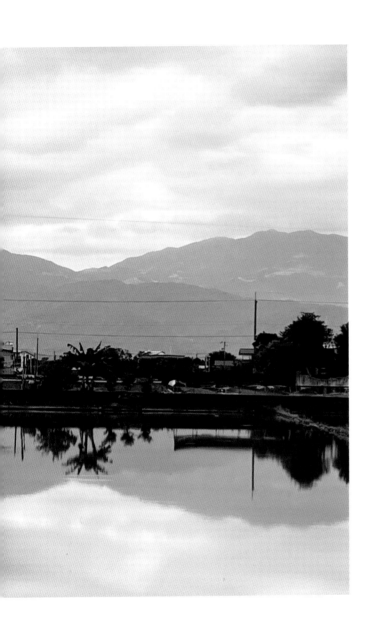

山光水影是鄉村最樸實容顏。〈宜蘭〉

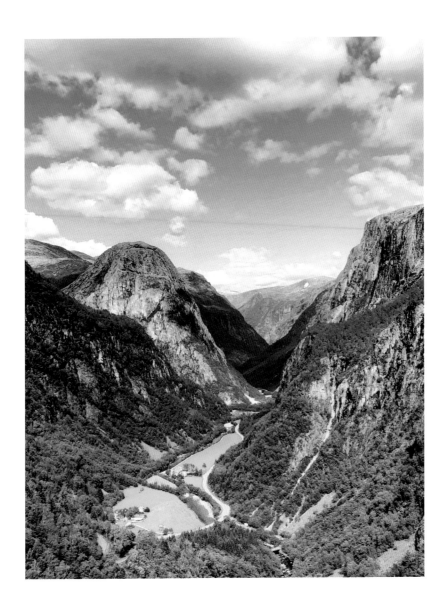

站在高峰遠望，就知道什麼是山川壯麗。〈北歐〉　　63

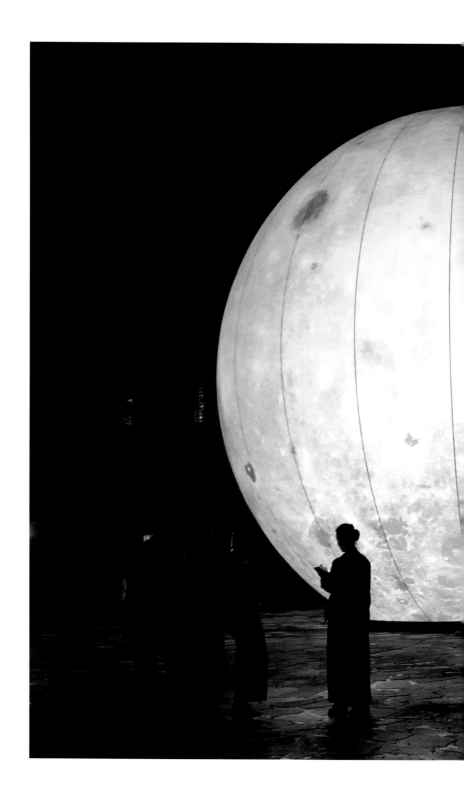

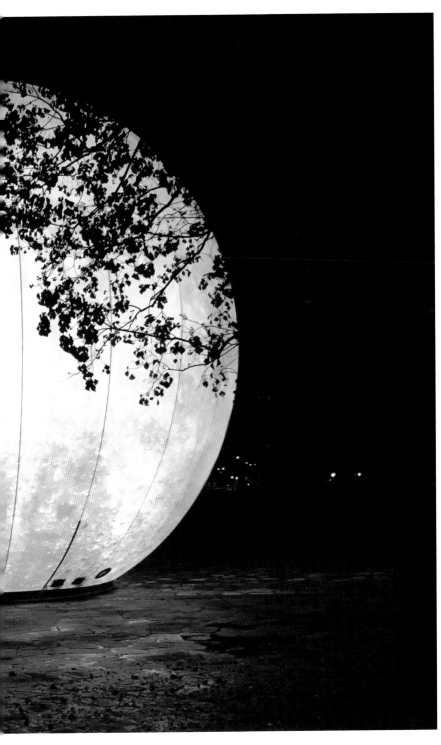

幽暗地心浮現虛幻的光色。〈宜蘭〉

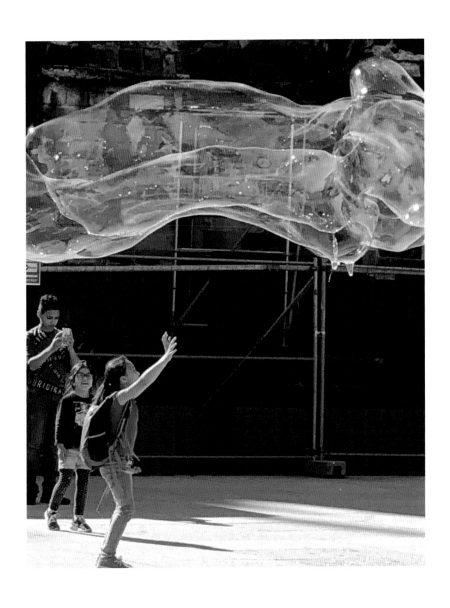

幸福歡樂的氛圍，存在剎那片刻。〈比利時〉　　67

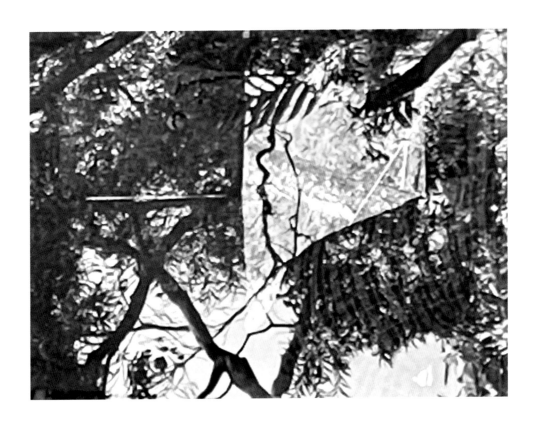

仰望窗影風動搖曳的疏葉。〈台中 · 飛花落院〉　　69

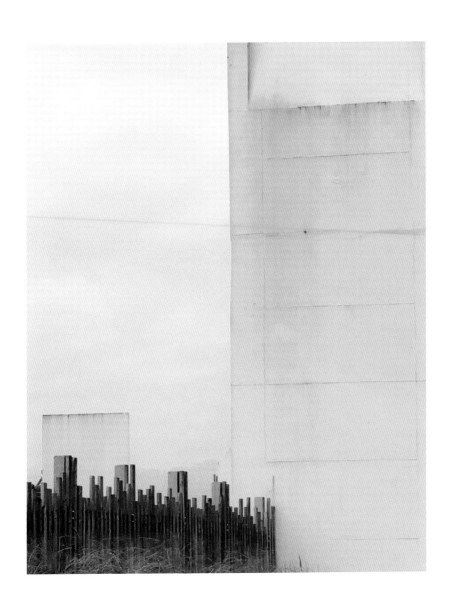

眾多樓宇中，唯我艷黃色相令人注目。〈宜蘭・壯圍沙丘〉　　71

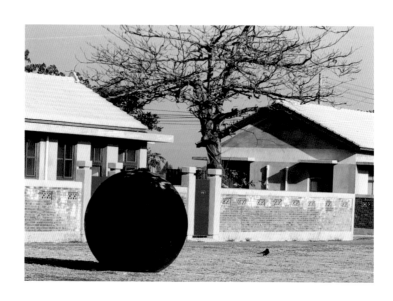

舊屋也有著人文的味道。〈台南 · 北門〉

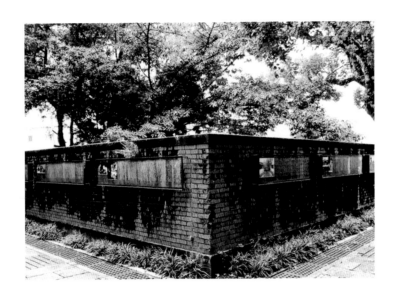

斑駁紅牆披掛著滄桑的外衣。〈宜蘭 · 礁溪〉　　73

年輪雕塑蒼鬱木牆與綠葉相襯著歲月的妝容。

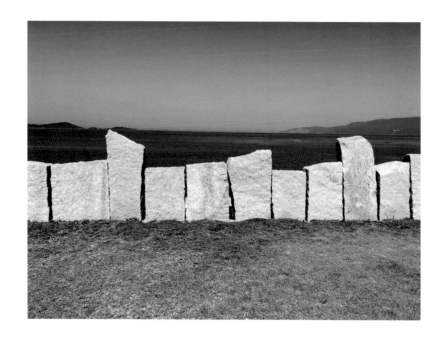

高矮胖瘦排排坐日光浴。〈日本〉

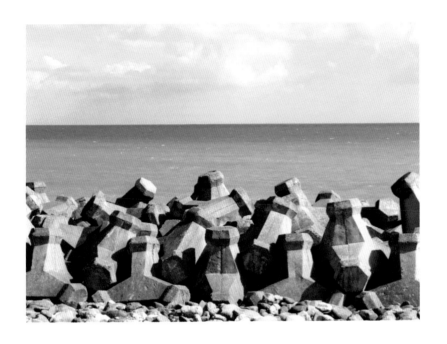

海岸邊鏤刻著歲月履痕。〈日本〉　　77

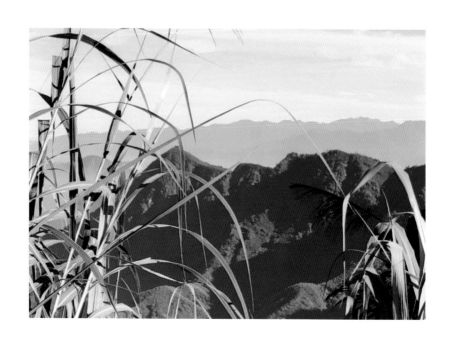

78　　　風吹醒了沉睡的群山。〈南投 · 溪頭〉

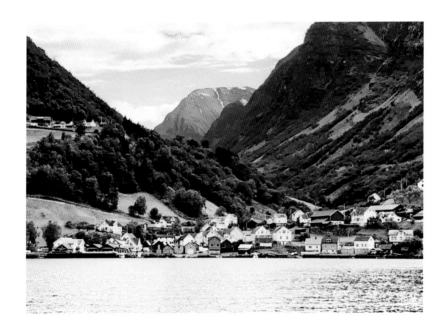

彩色的房舍，妝點了蒼綠的山景。〈挪威 ‧ 松恩峽灣〉

在寬闊的綠蔭同遊，聽風吹動枝葉的絮語。〈彰化 · 成美文化園區〉

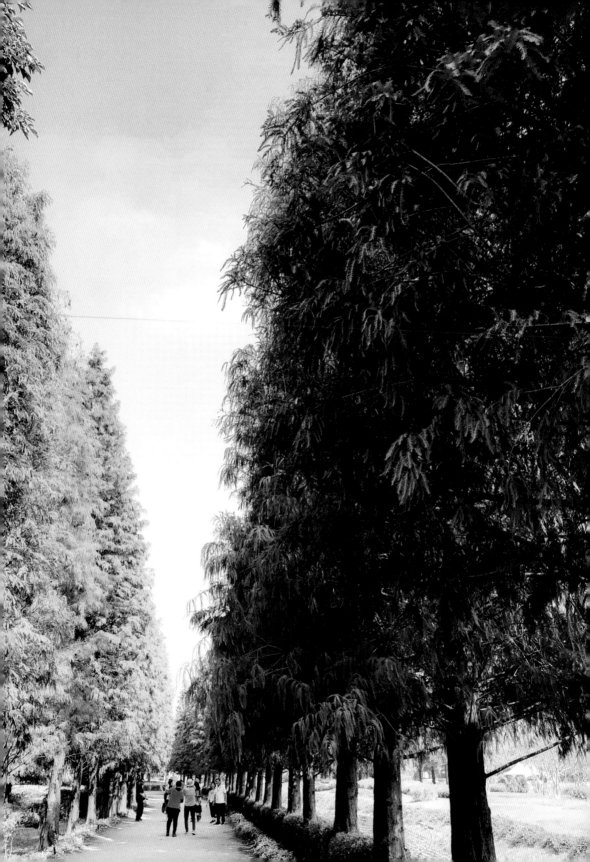

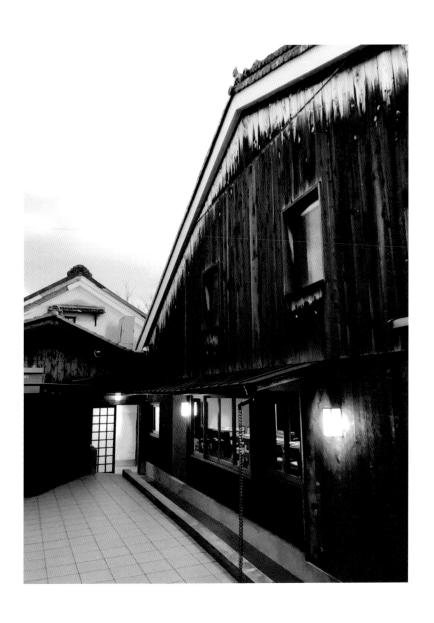

寒夜中，適合煮茶或煮酒。〈日本・京都〉

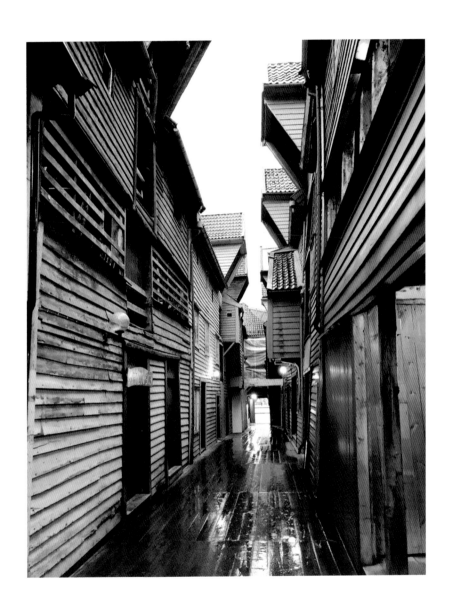

蕭瑟的微雨，帶來幾許的涼意。〈芬蘭〉

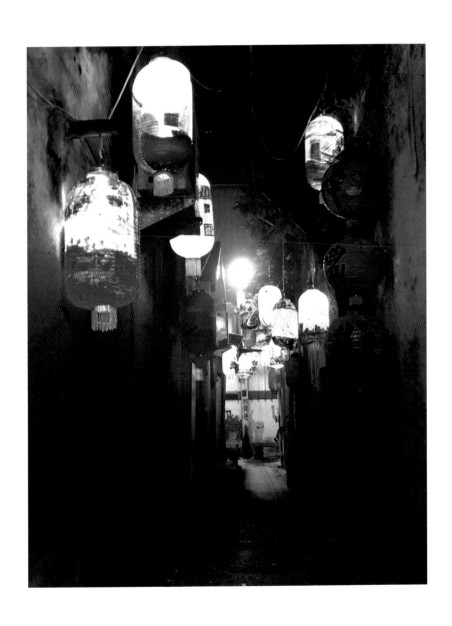

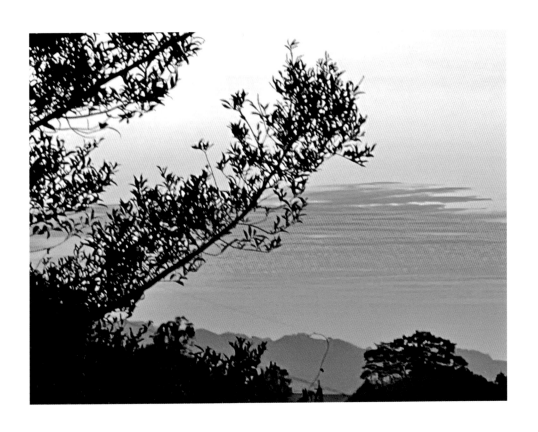

向晚的雲霞輕盪著彩度。〈苗栗 · 舉目山莊〉　　89

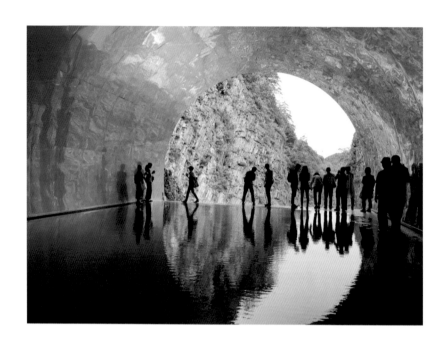

尋幽探秘桃花源在何處？〈日本〉

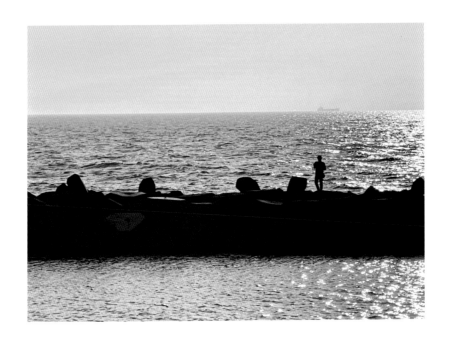

波光粼粼金陽下，靜聽水流起舞。〈古巴〉　　91

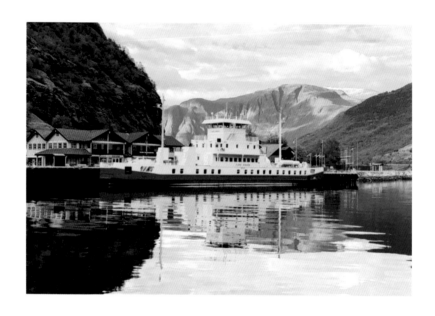

這是真實彩色繽紛的童話國度。〈挪威 · 松恩峽灣〉

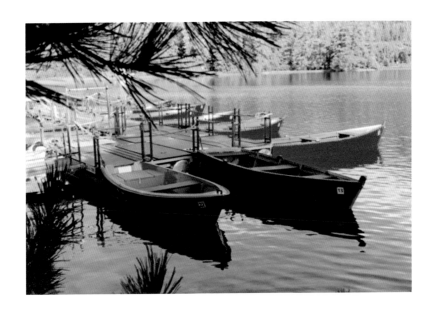

小船帶領旅人划向艷麗的旅程。〈斯洛伐克 · 什特爾巴斯卡湖〉　　93

一碧蒼穹下，築起剛健的線條。〈高雄 · 大港橋〉

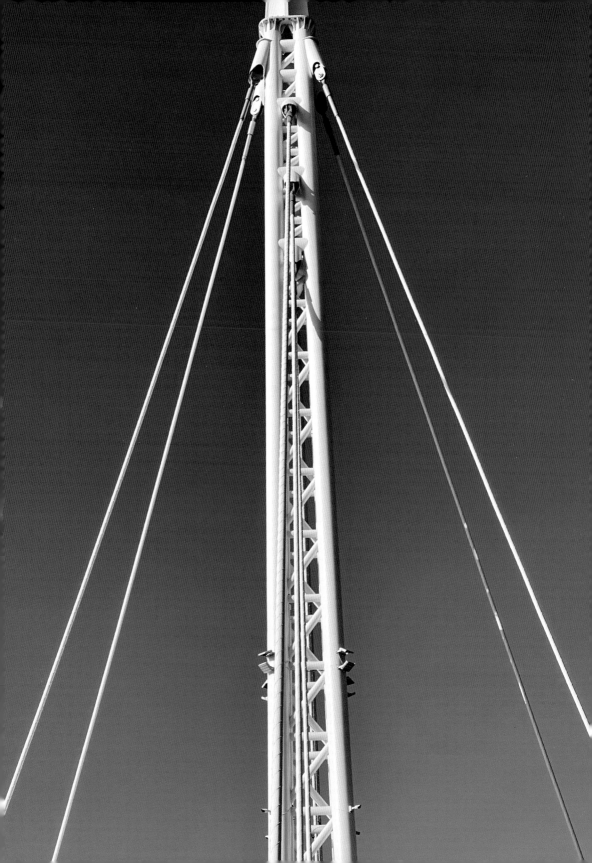

蔬果交織化作人間豐盈美味。〈高雄 · 晶英西餐廳〉　　97

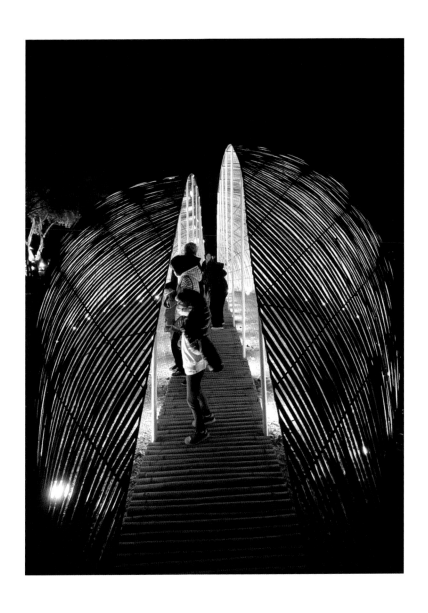

踏進朦朧光影中尋覓幽徑的神秘。〈台南 · 鹽水〉

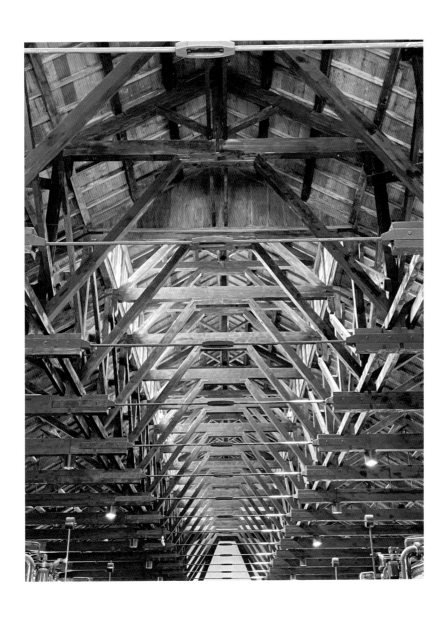

層層疊疊、疊疊層層構築了宏大的帷幕。〈台南 · 水道博物館〉

探尋未知無法估量的深淵。〈北京〉

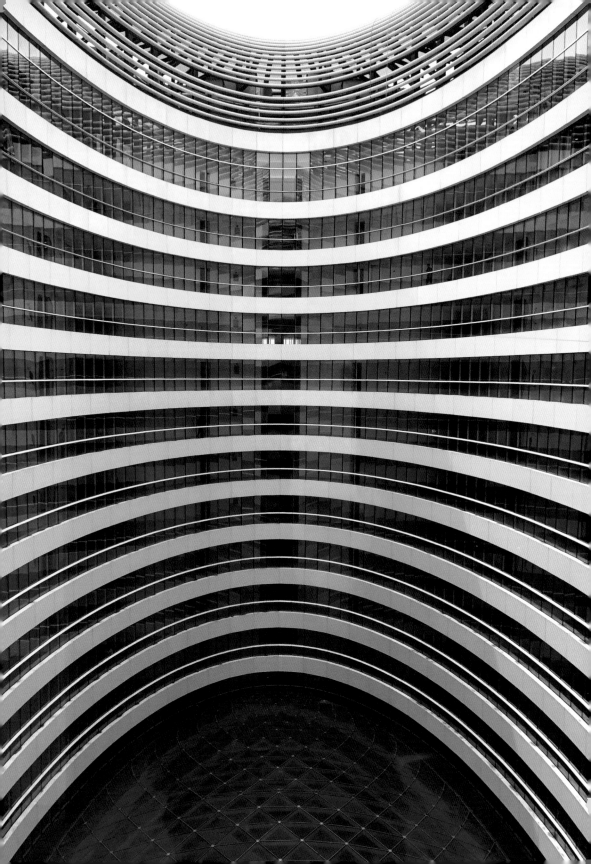

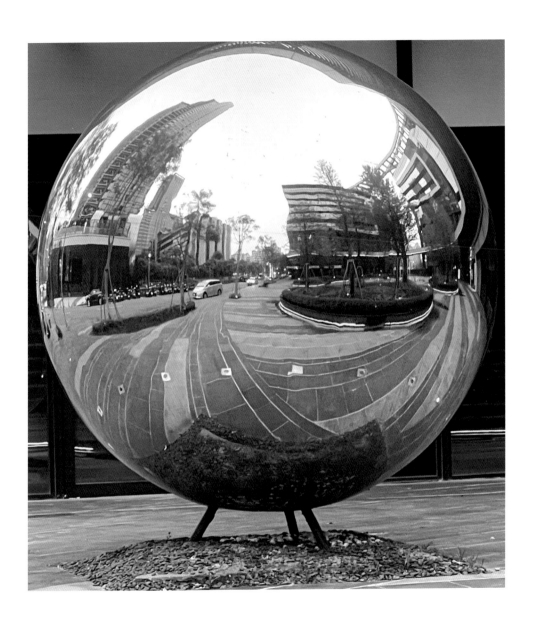

廣闊圓亮鏡面中，收羅都會萬象景觀。〈台北 · 萬豪酒店〉

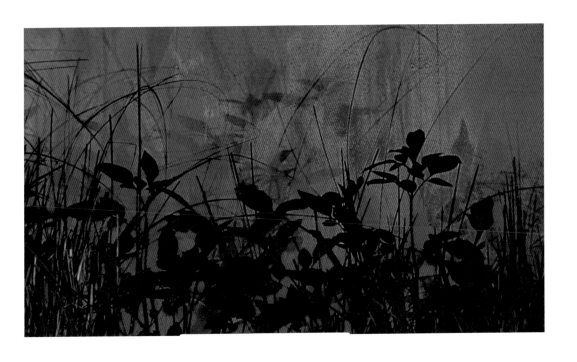

朦朦朧朧葉隙間飄動著姹紫嫣紅的幻影。〈台北 · 陽明山〉　　107

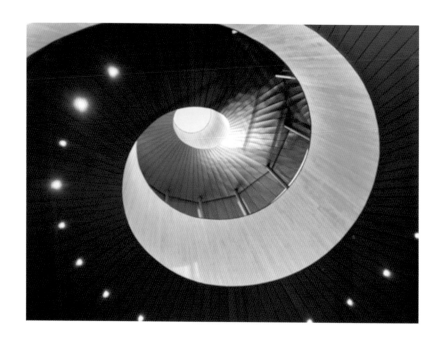

　　　窄縫中散發奇特迴旋的光點。〈屏東〉

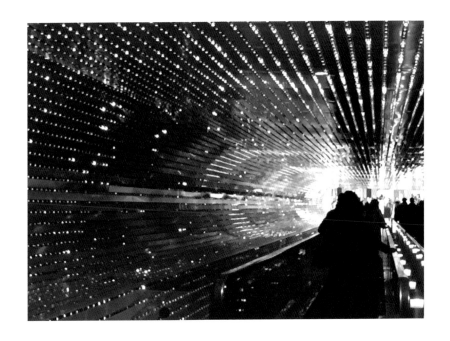

窗外水珠化為繽紛的精靈，到處飛舞。〈墾丁 · 華泰瑞苑〉

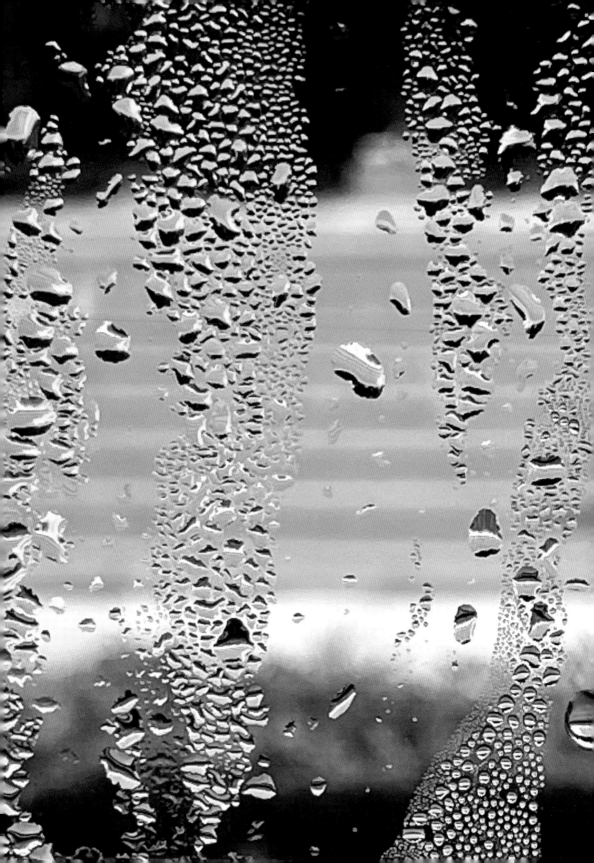

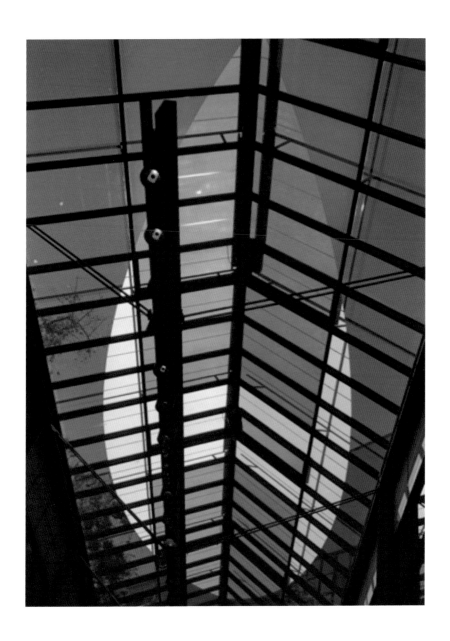

陽光總是喜歡依戀高大的樓台。〈歐洲〉　　113

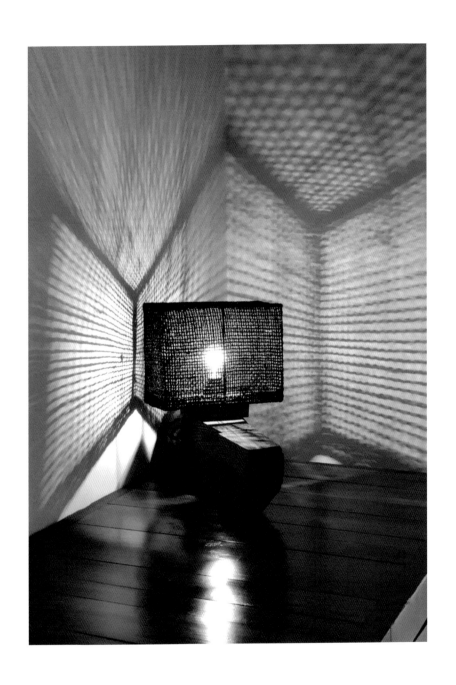

光可以繡出直橫交叉萬丈的線條。〈日本・小豆島〉

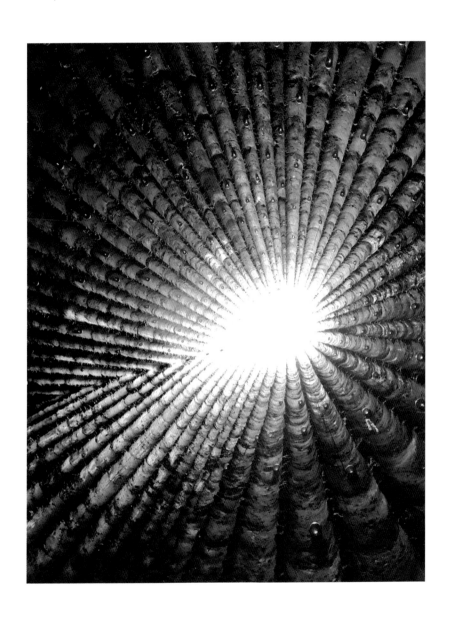

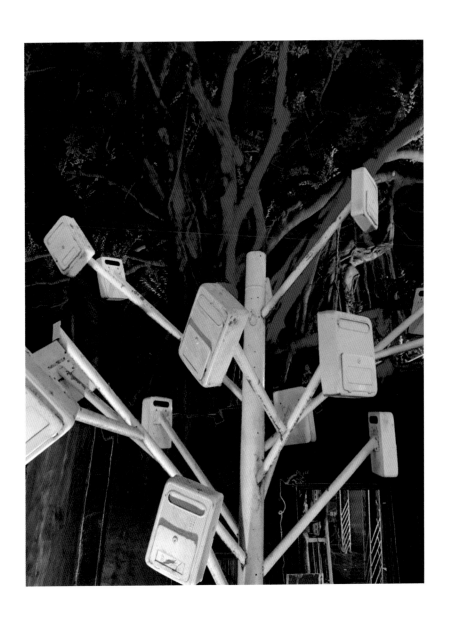

藍光為綠樹照映色彩，呈現尋幽探秘趣味。〈台南〉 119

風景可以不同角度凝視奇特的畫面。〈台北 ‧ 北美館〉

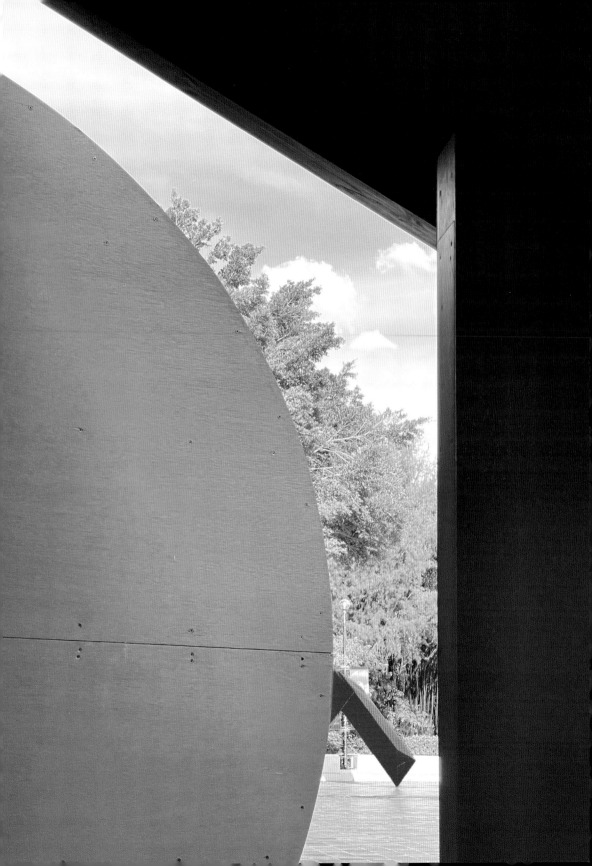

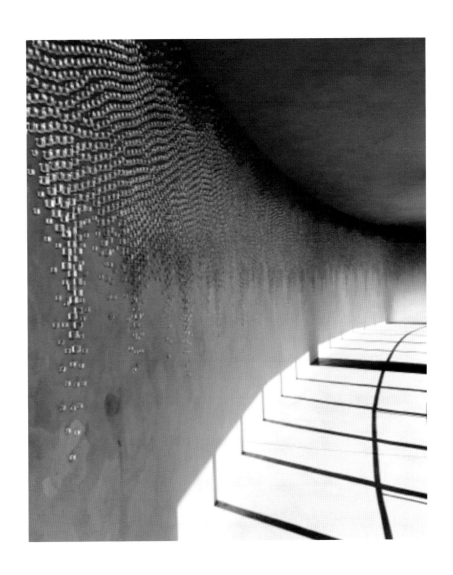

在長廊慢慢踱步的光。〈日本 · 瀨戶內海〉　123

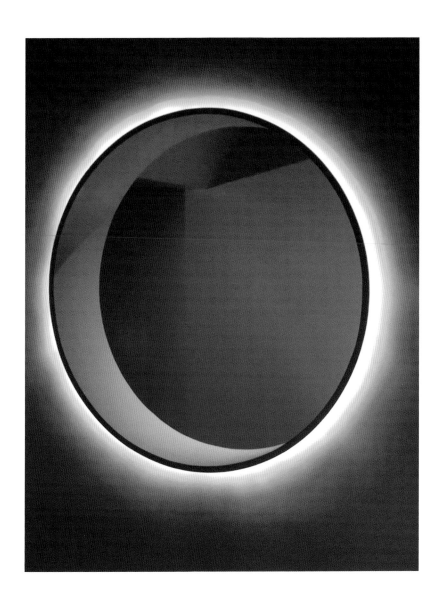

潔淨的圓融光暈，綻放迷人感魅的輪廓。〈台東 · 那界行館〉

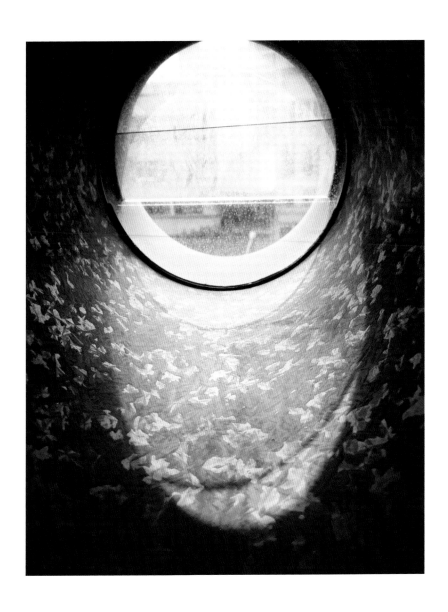

忽明忽隱縹緲迷離景象，呈現極度空靈幻影。〈台中 · 路思義教堂〉　127

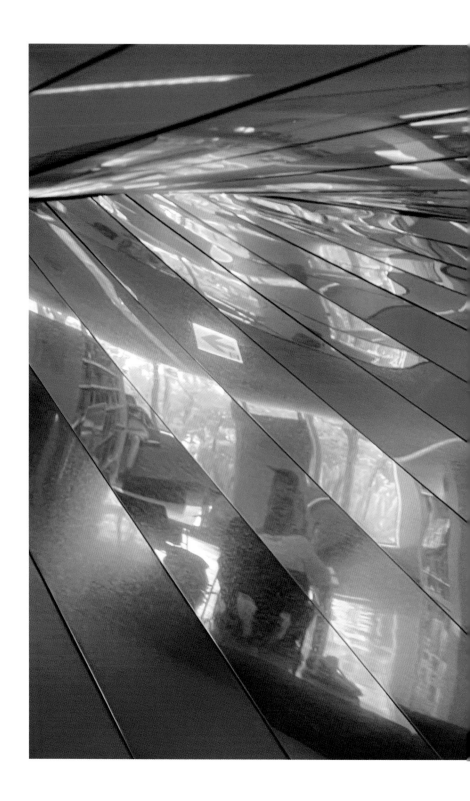

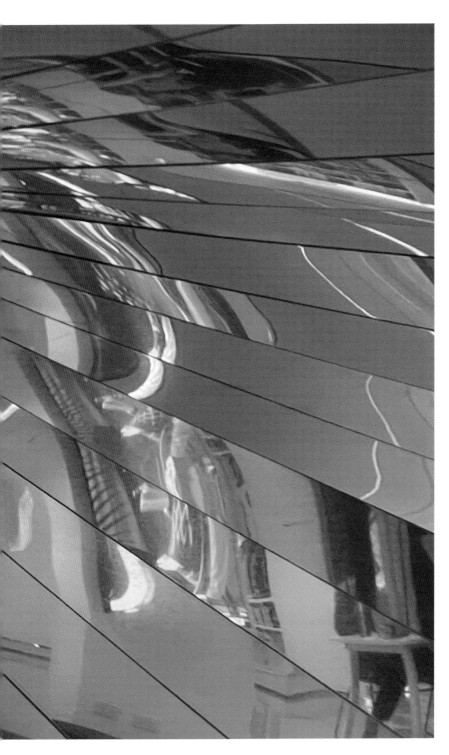

空間可以幻出豐碩瑰麗的大千世界。〈屏東 · 縣立圖書館〉

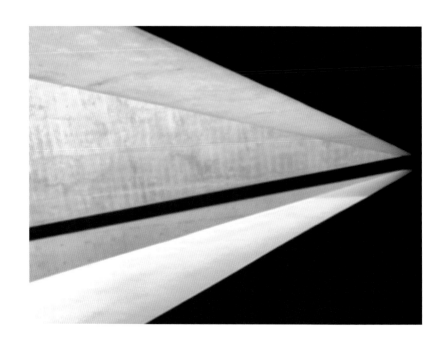

　簡約美學的極致。〈日本〉

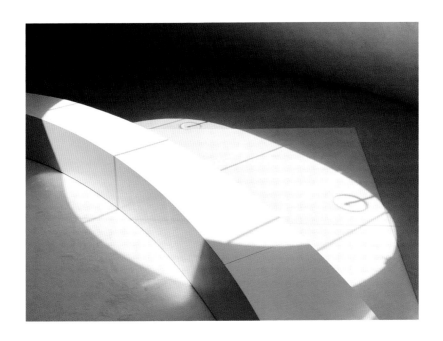

光是攝影師手中的畫筆。〈日本 · 豐島〉　　131

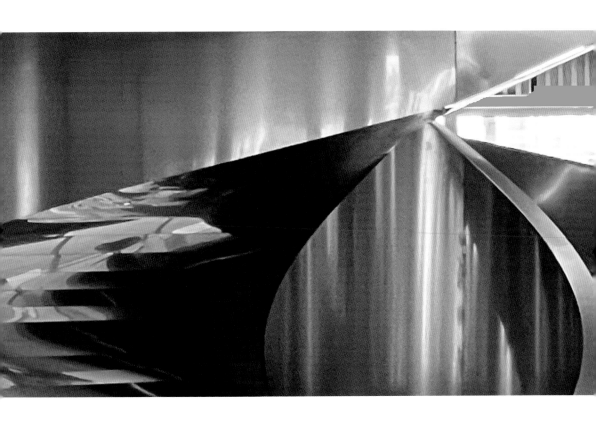

牆面化作抽象曲線和模糊不清的輪廓。〈屏東 · 縣立圖書館〉　　133

一盞燈為寂靜帶來溫度。〈台中 · 飛花落院〉

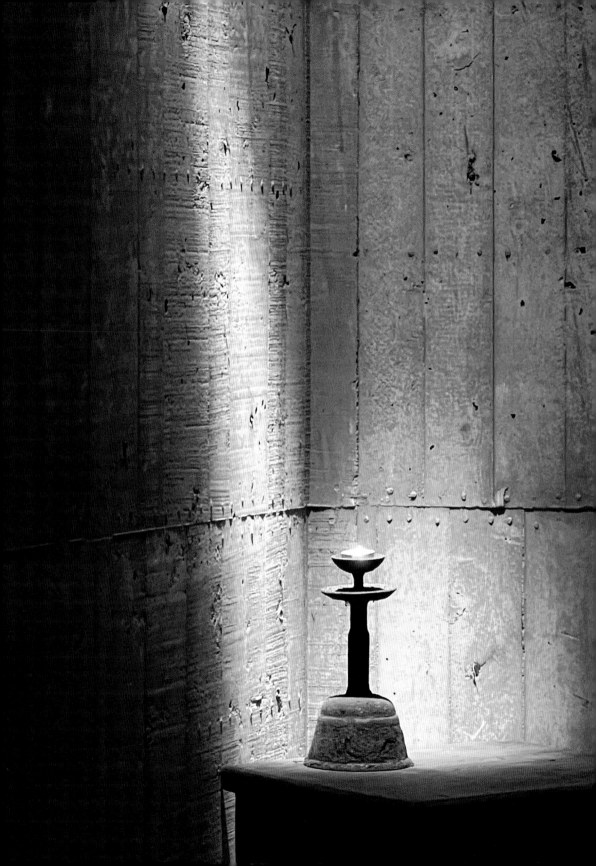

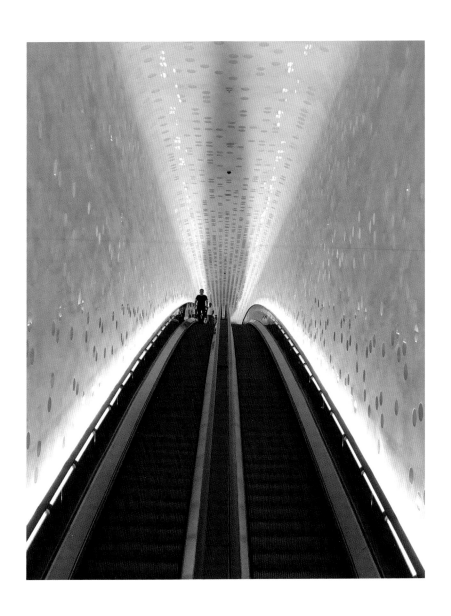

你要通往華麗深不可測的仙境？〈德國 · 漢堡易北音樂廳〉　　137

熾熱的光，溶出萬般酷烈綺麗的顏色。〈台北 · 陽明山〉 139

瑰麗跳動幻影中，成了最美麗豐碩的視覺魅力。〈歐洲 · 舊煤礦區遺址〉　　141

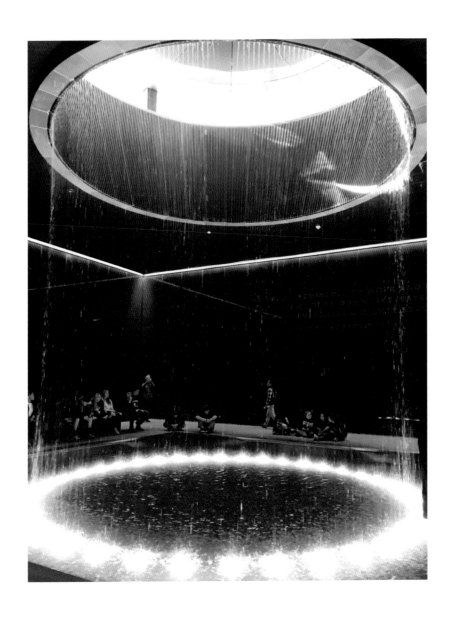

光束線條宛如一個晶亮小宇宙。〈日本〉　　143

宛若流星珠玉、垂落萬千光輝。〔越南〕

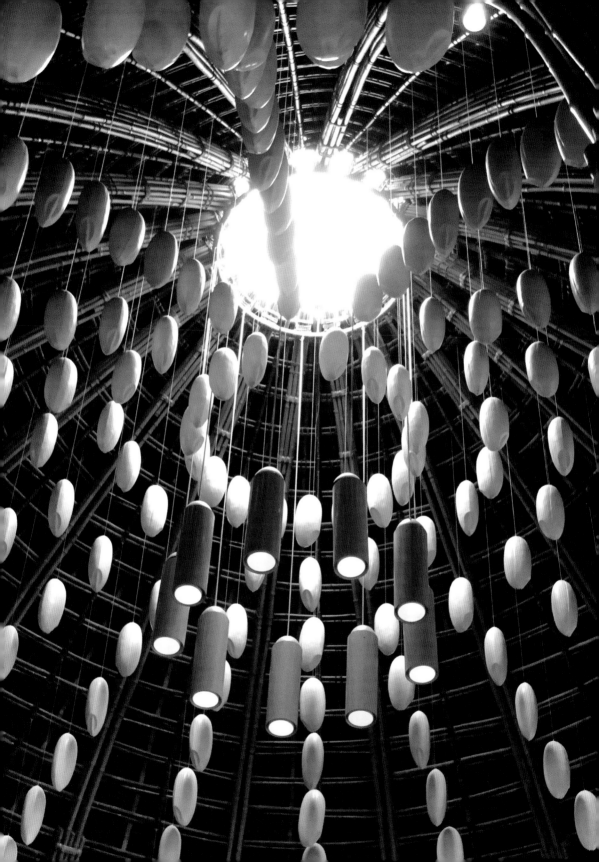

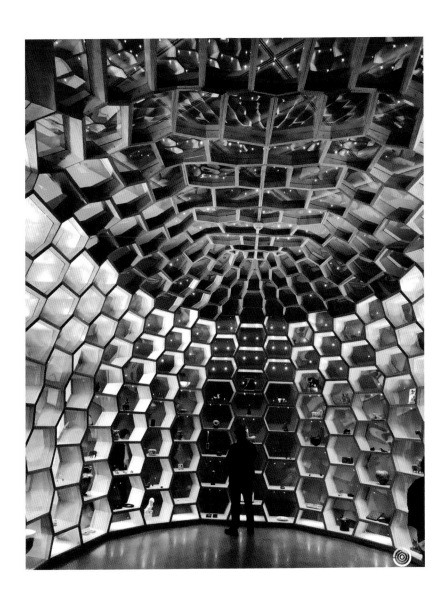

毫無章法的空間，迸出無限的想像。〈歐洲〉

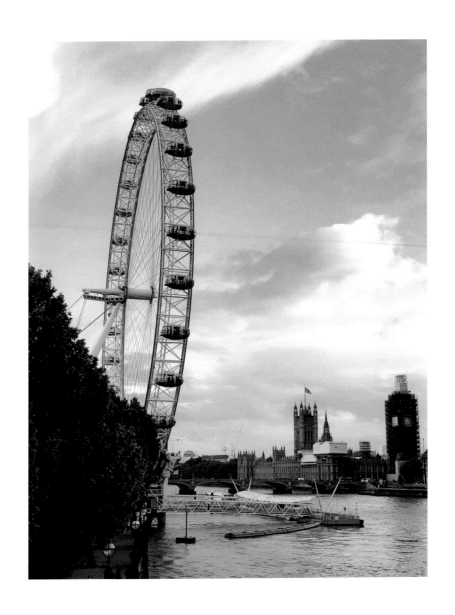

不同的高度，就有不同的視野。〈英國　‧　倫敦〉

夕陽的魅力，永遠嫵媚著每一天。〈內湖 ‧ 大直〉

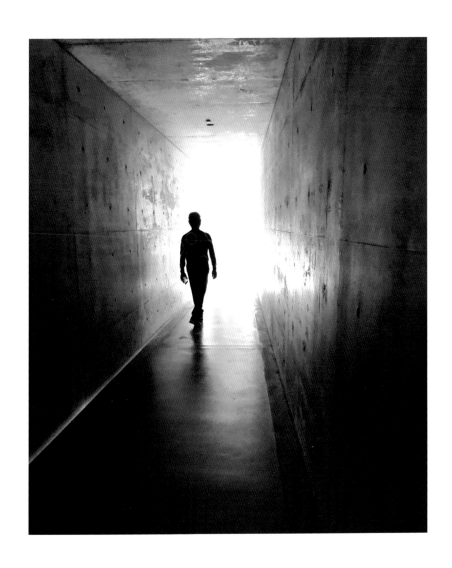

你要穿越光的宇宙？〈日本・直島〉（友人拍攝許義榮的背影）

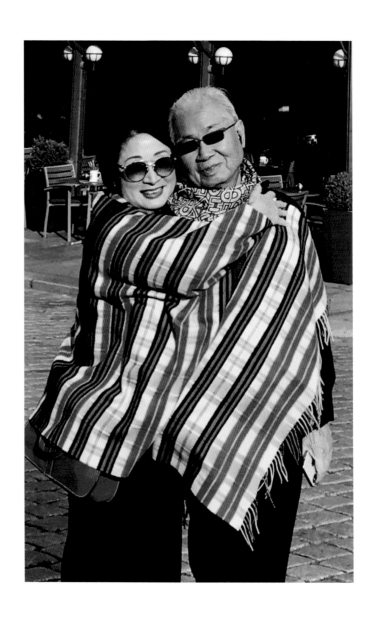

許義榮總裁和夫人楊麗芬同遊德國德勒斯登留影。

作者簡介

許義榮

1942 年出生於台南，畢業於台北淡江大學商學系，是大原 / 信源企業之創辦人，現為信源企業總裁，擁有 50 年豐富的成衣生產管理經驗，帶領信源一步步邁向國際化，持續擴展信源經營版圖。

參加台北北區扶輪社，社齡超過 40 年，曾擔任 2007~2008 年度社長，熱衷公益及社會服務活動，對慈善事業亦不遺餘力，各類慈善機構的捐款、藝文支持、重大災難的捐贈並長期贊助 Room to Read 在世界各地興建教室及提供獎助學金，落實企業社會責任。

閒暇之餘，喜歡攝影，無論在國內、外出差、旅遊，常常拾起手機，拍下感動的一刻。

About the Author

Mr. James Yi-Rong Hsu is the Founder and Chairman of Reliable Source Industrial Group (RSI), a premium activewear manufacturer. He was born in Tainan, Taiwan in 1942 and graduated from Tamkang University with a degree in business. With over 50 years of leadership and management experience in apparel manufacturing, Mr. Hsu has spearheaded the global expansion of RSI and continues to oversee its strategic business growth.

Mr. Hsu has been a dedicated Rotary Club member for over four decades and served as the President of the Rotary Club of Taipei North between 2007 and 2008. As an active philanthropist, he is deeply committed to social welfare issues and has supported many charity organizations to promote the arts as well as to support local disaster relief. He has also long supported Room to Read, a leading global nonprofit for children's literacy and girl's education, and funded efforts to build libraries and educational programs for school children around the world. These efforts exemplify his strong belief in corporate social responsibility.

He has a keen interest in photography. Whether during business trips or his personal travels in Taiwan or abroad, Mr. Hsu enjoys taking photos with his mobile phone to capture the many heartwarming moments he sees along the way.

逐光紀影 / 許義榮作 . -- 初版 . -- 臺北市：時報文化出版企業股份有限公司 , 2022.09
　面；　公分 . -- (Origin；29)
ISBN 978-626-335-931-4(精裝)

1. CST: 攝影集

958.33　　　　　　　　　　　　　　　　　　　　　　　　　　　111014338

ISBN 978-626-335-931-4
Printed in Taiwan

Origin 29

逐光紀影

作者　許義榮 ｜ 照片提供　許義榮 ｜ 監製　信源企業股份有限公司 ｜ 藝術總監　梁小良 ｜ 視覺設計　許瑞玲 ｜ 編輯協力　謝翠鈺 ｜ 企劃　鄭家謙 ｜ 董事長　趙政岷 ｜ 出版者　時報文化出版企業股份有限公司　108019 台北市和平西路三段 240 號七樓　發行專線—(02)2306-6842　讀者服務專線—0800-231-705 ・(02)2304-7103　讀者服務傳真—(02)2304-6858　郵撥—19344724 時報文化出版公司　信箱—10899 臺北華江橋郵局第九九信箱　時報悅讀網—http://www.readingtimes.com.tw 時報出版臉書—http://www.facebook.com/readingtimes.fans ｜ 法律顧問　理律法律事務所　陳長文律師、李念祖律師 ｜ 印刷　和楹印刷有限公司 ｜ 初版一刷　2022 年 9 月 23 日 ｜ 定價　新台幣 680 元 ｜ 缺頁或破損的書，請寄回更換

時報文化出版公司成立於 1975 年，並於 1999 年股票上櫃公開發行，
於 2008 年脫離中時集團非屬旺中，以「尊重智慧與創意的文化事業」為信念。